My New New York Diary
Julie Doucet & Michel Gondry

PictureBox, Brooklyn

Julie Doucet is awesome. Her work portrays the most violent secrets of the human heart. She has an uncompromising perspective on what is going on underneath a girl's skin—which is great when you're a boy and you grew up with only brothers. Male sex mutilation, poop, anger, abusive boyfriends, virginity's burden, and period inconveniencies constantly burst off the page in her black ink. If you thought women were more romantic than men, forget about it.

I had this idea I always wanted to try with a comic book artist, an idea that derived from the art form itself. Autobiographical comics are like autobiographical novels: the story revolves around the author's character. The author is constantly present, and because comics are drawing-based, becomes overwhelmingly prominent. Yet he or she is not part of the story on the same level as all the other characters are, because he or she is also functioning as "the camera." Autobiographical comics give the artist a special status that I thought I could illustrate by replacing his or her drawn representation with a video image. That was my idea: I would shoot Julie on a blue screen, replacing her drawn image in each frame of the story by having her re-enact what her character is doing on the page. She would be the only "live" character in her graphic universe. I know it doesn't sound groundbreaking, but watching the artist herself evolving inside the very drawings she had done is pretty cool, if you ask me.

The funny thing is, from her work you would expect Julie to be confident, rugged, jaded, and covered with tattoos. Yet she is not—she is squarely the opposite. Julie was utterly terrified and repulsed by the idea of standing in front of a camera. I had to use inexcusable and manipulative means to convince her to do it. But I had to. My concepts are like kidney stones to me: very painful to expel, but worse to hold in. I succeeded.

After agreeing to my plan, her next question was, "What is the story?" "Well, the story is...you coming to New York to visit me and shoot this project, me explaining the concept...," etc. Since she already wrote *My New York Diary*, this would be called *My New New York Diary* and be tinted by the melancholy of reminiscence, which would at the same time satisfy my nostalgic bulimia. —*Michel Gondry*

Introduction

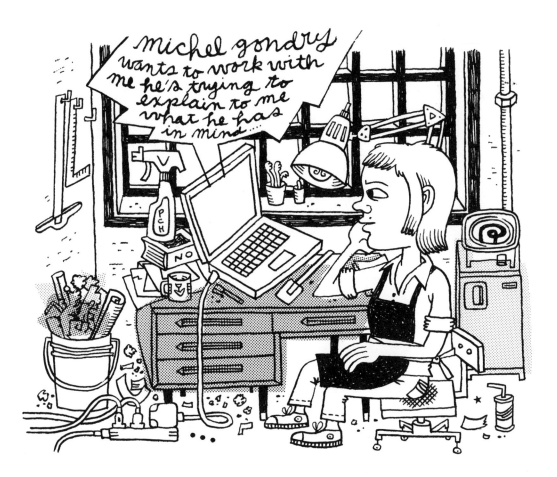

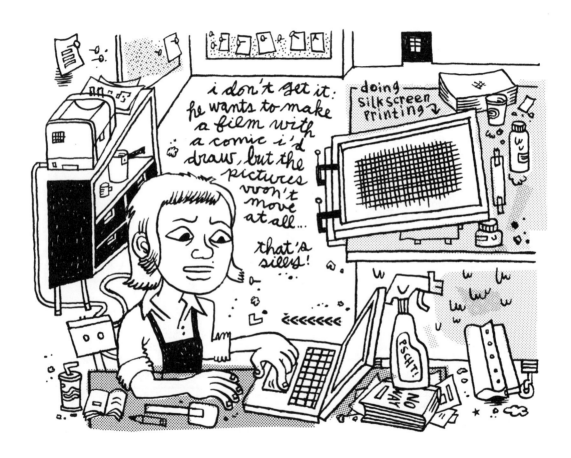

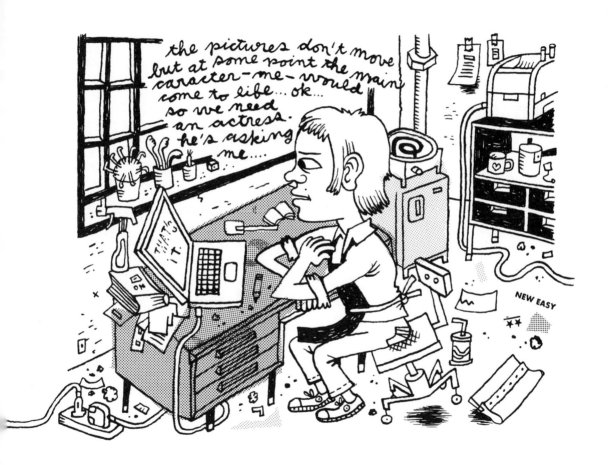

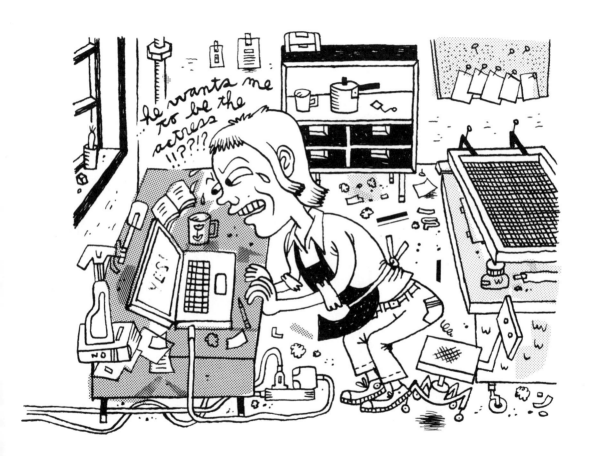

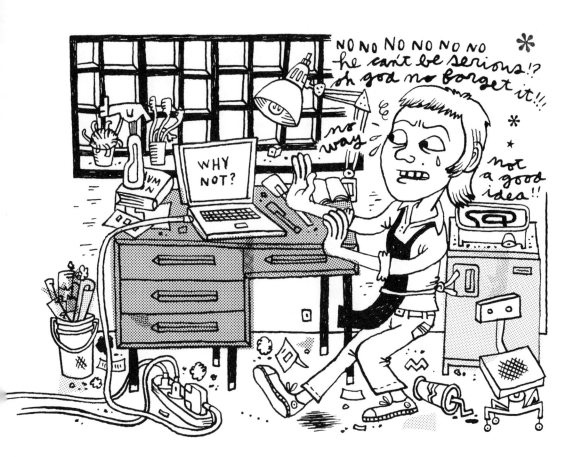

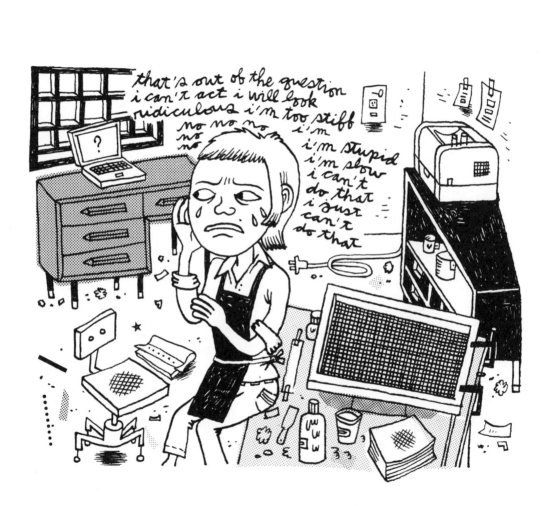

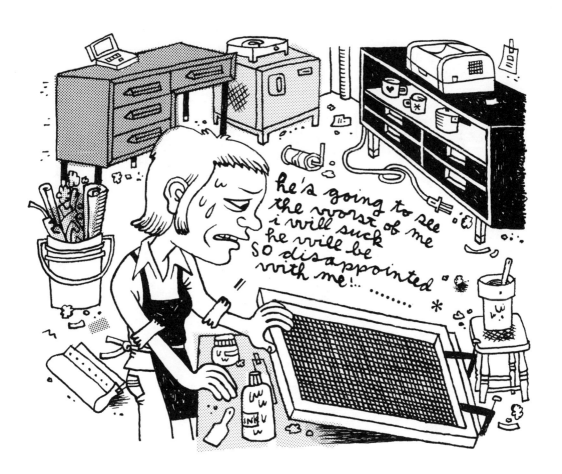

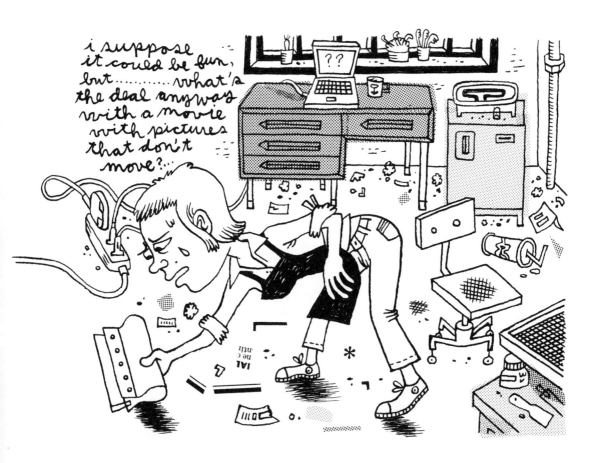

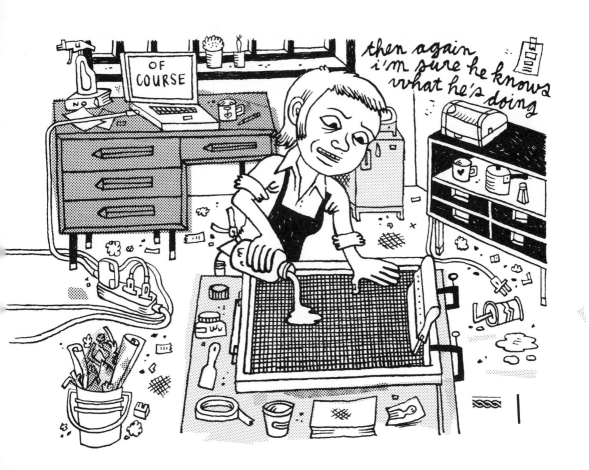

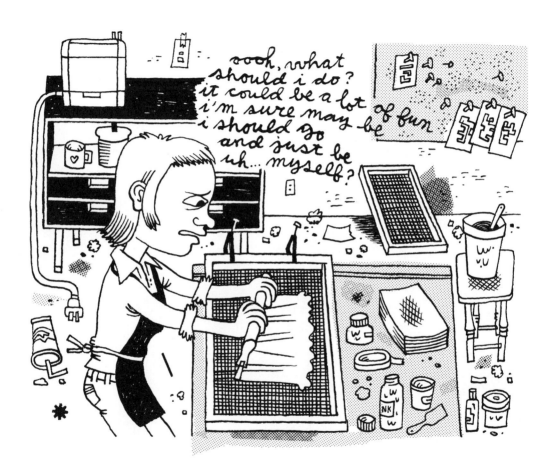

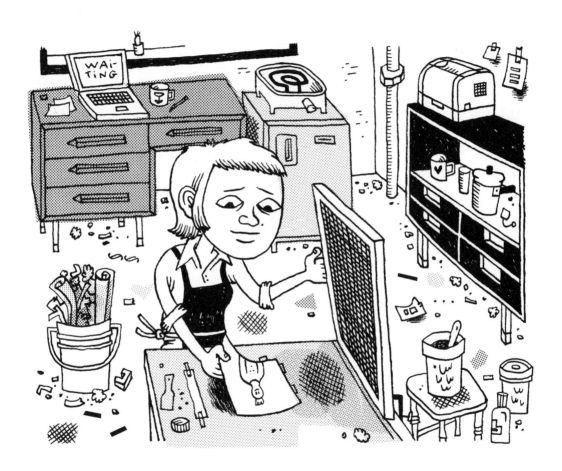

waiting...

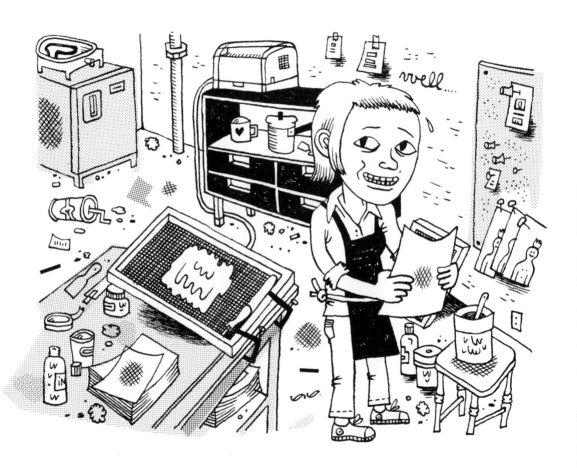

Michel asked me to buy a tape recorder to put my voice in the movie.

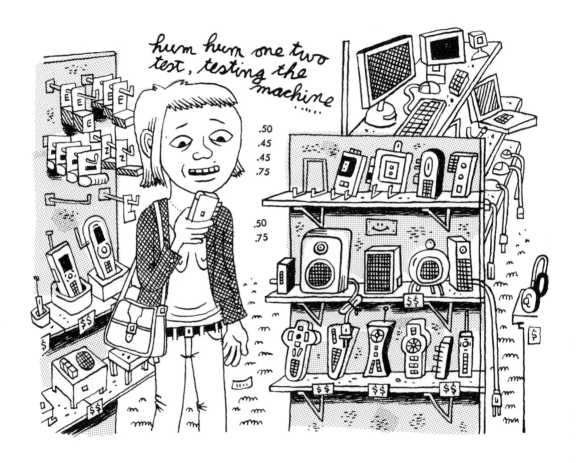

hum hum one two test, testing the machine...

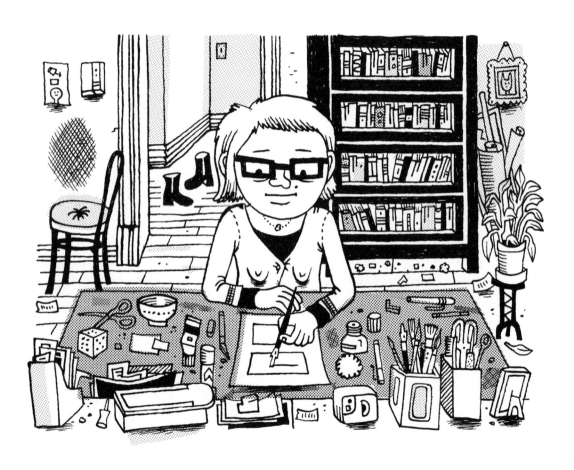

the next day i started to work on the film...

...and the next day...

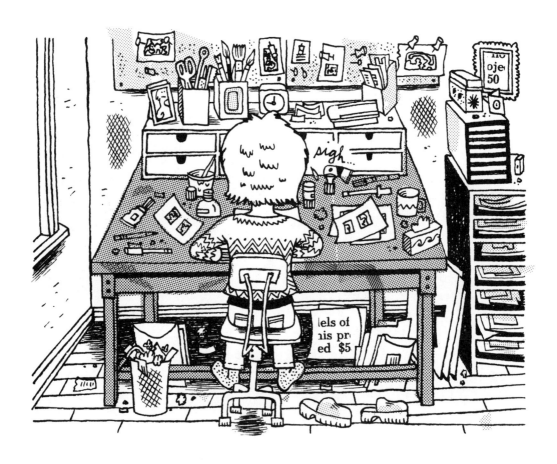

...and the day after the day after...

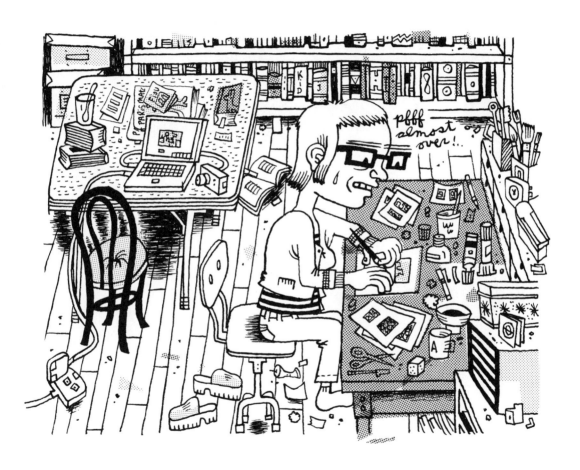

...and so on and so on...

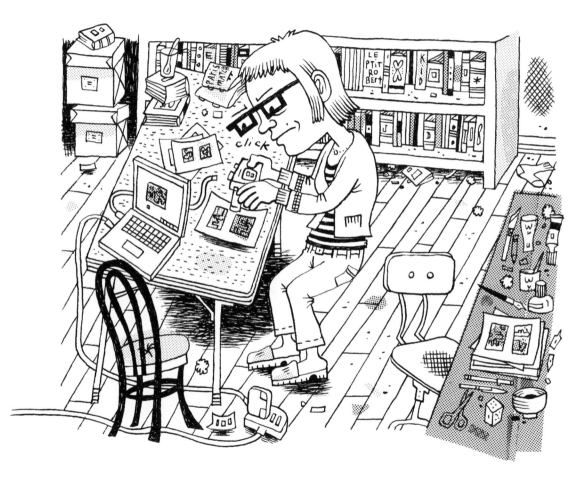

...until it was time to leave.

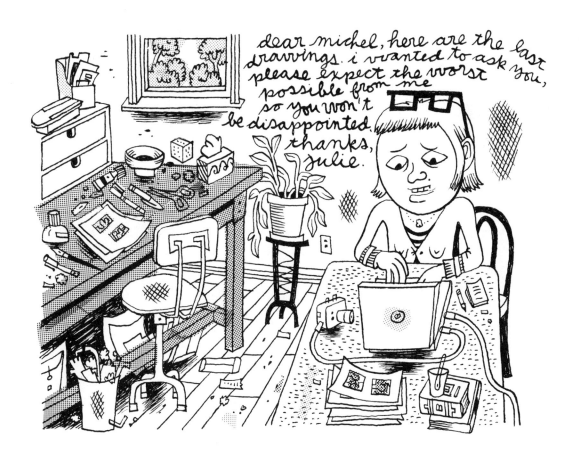

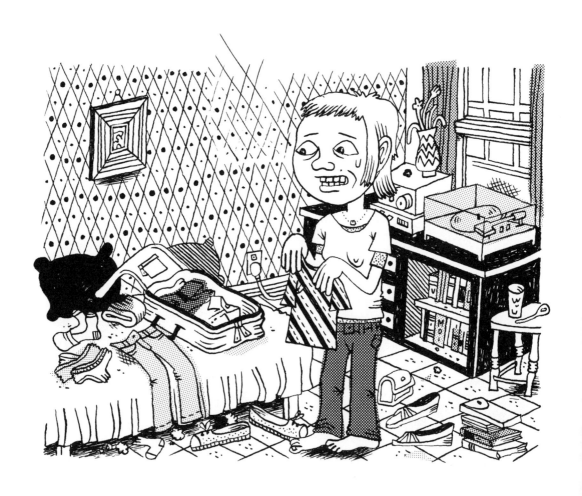

time to pack up my bags.

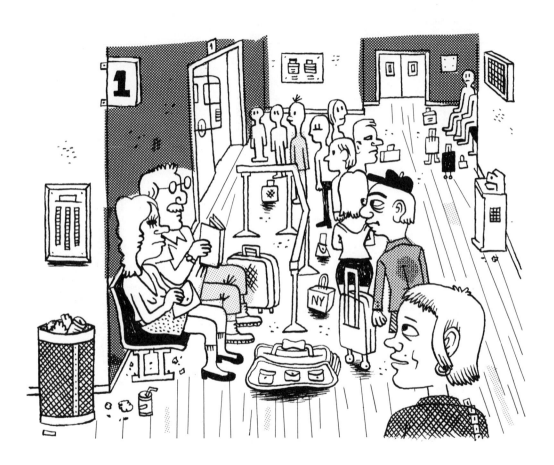

the next morning at the bus station.

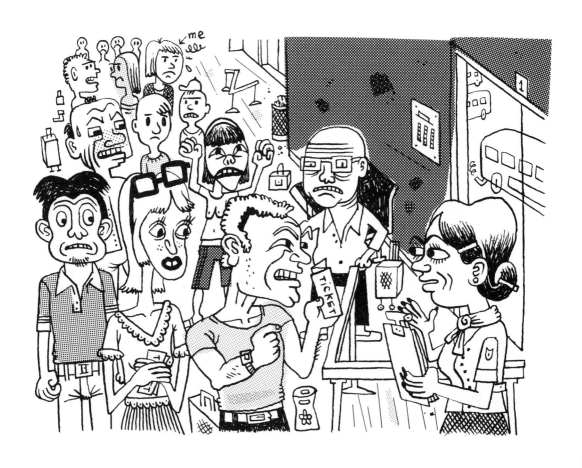

it turned out there were too many passengers for the bus.

i had two hours and a half to kill.

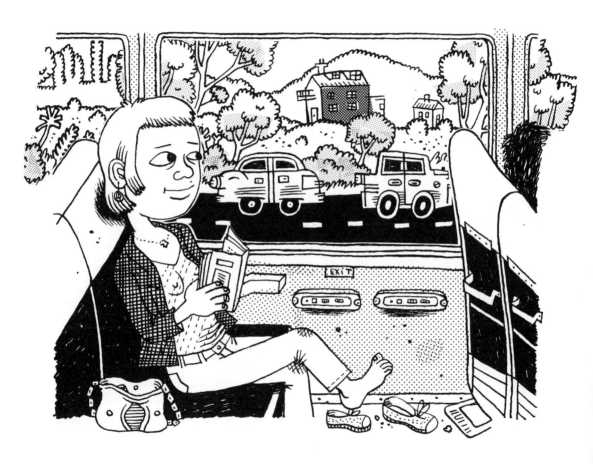

at last we got on the bus. i had two seats all by myself.

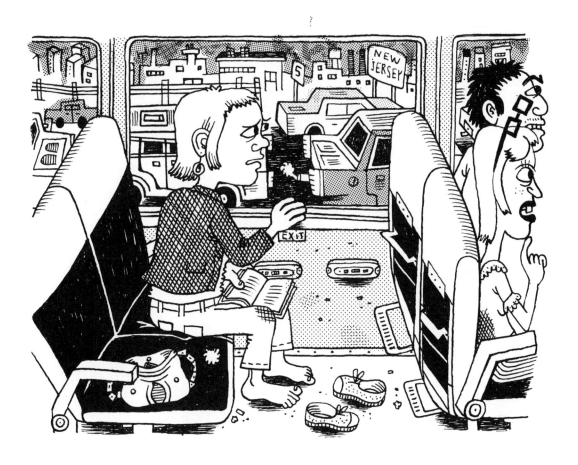

in New Jersey, we got stuck in a huge traffic jam.

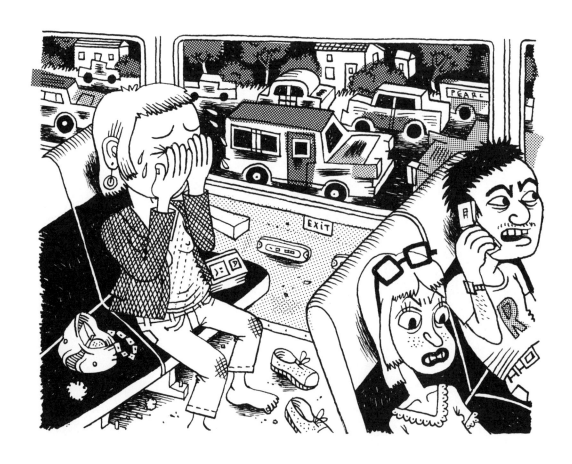

we lost two hours! i was freaking out.

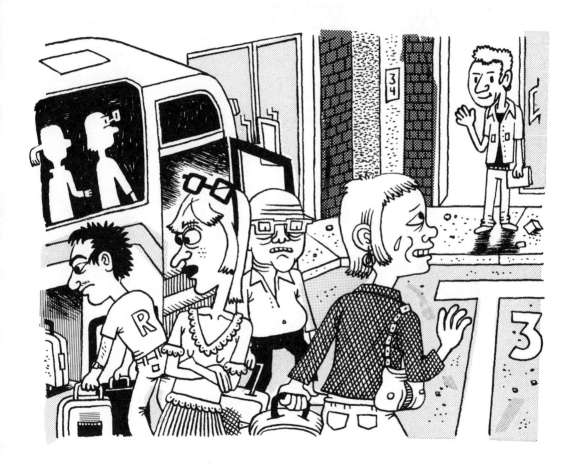

but Michel was there, waiting for me, looking happy to see me.

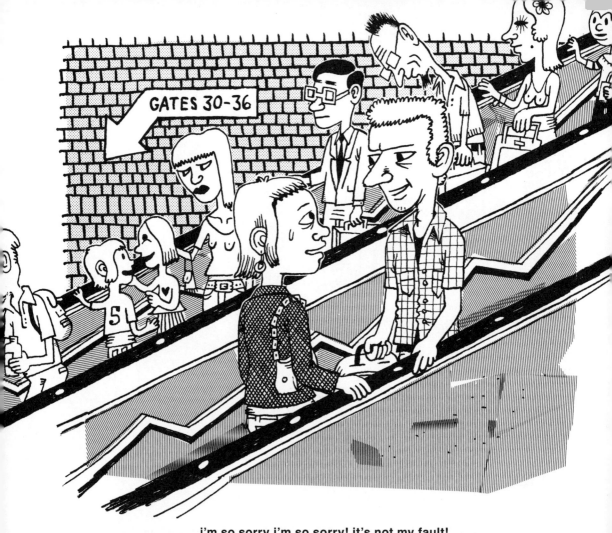

i'm so sorry i'm so sorry! it's not my fault!

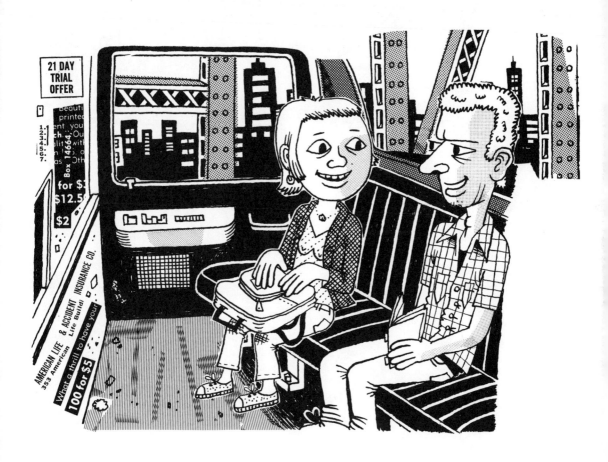

we took a cab. we were going to Michel's place and then the studio.

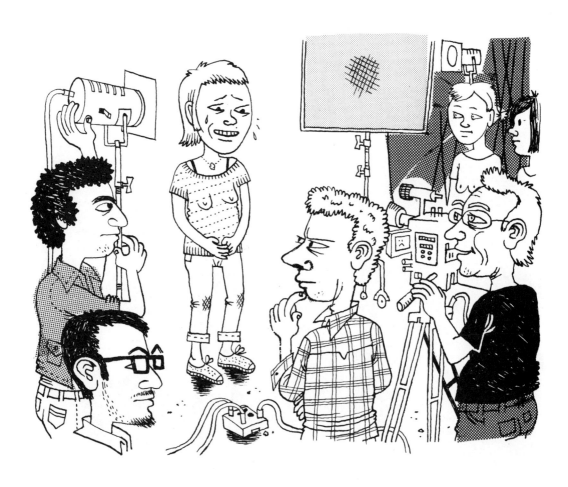

Michel shot me on a blue screen.

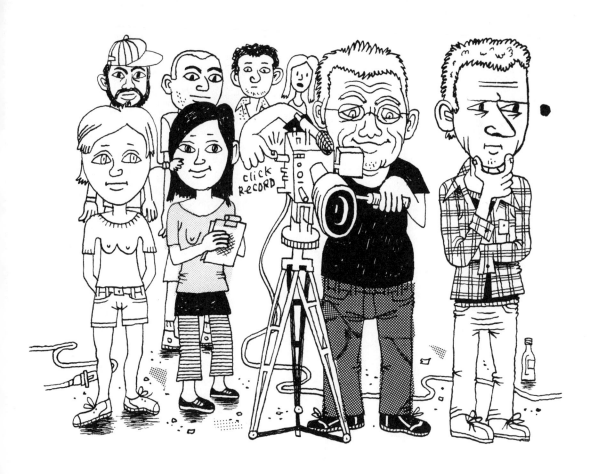

it was supposed to be just me and him in the studio.

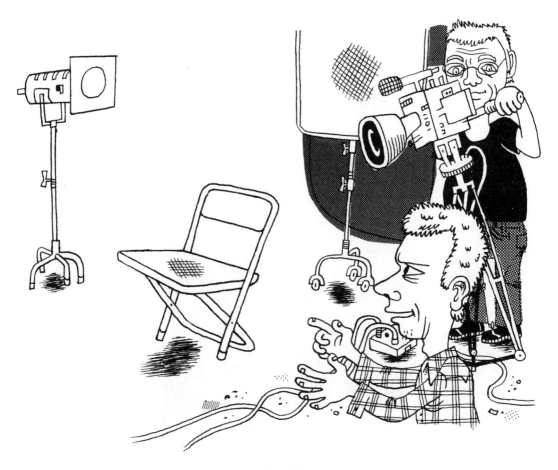

at this point i become real.

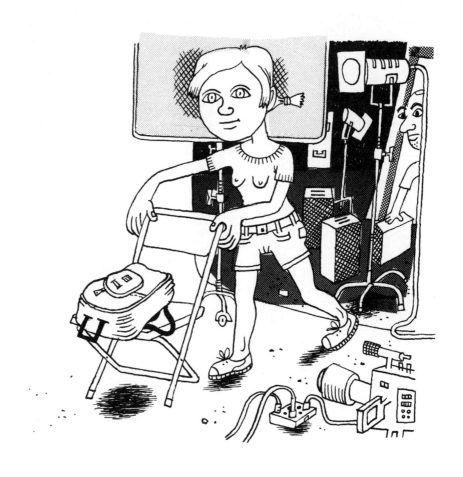

here i will be sitting in the taxi with Michel.

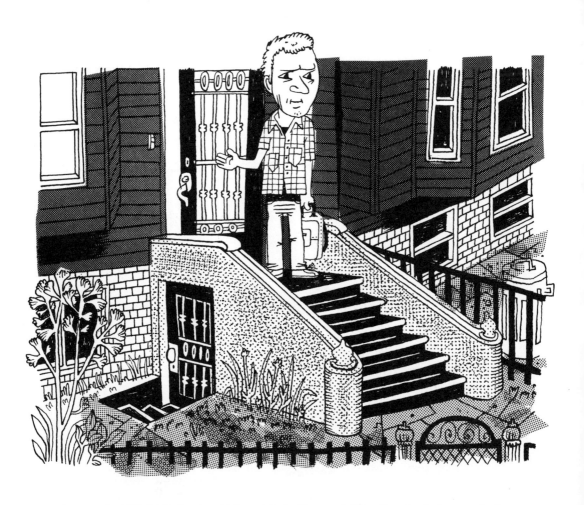

i expected Michel's house to be a big hollywood film director's house. but, no.

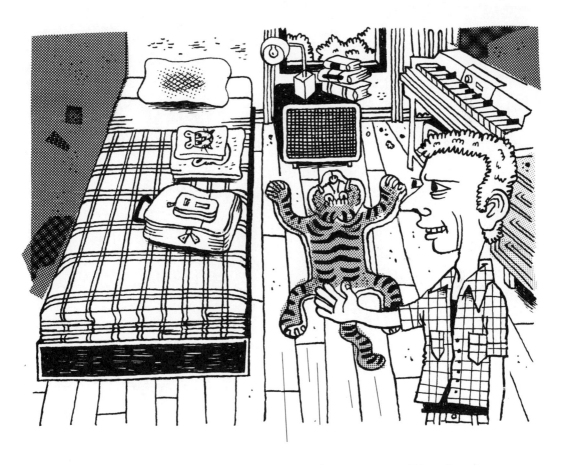

my bedroom. Michel had bought for me a tiger carpet and tiger towels.

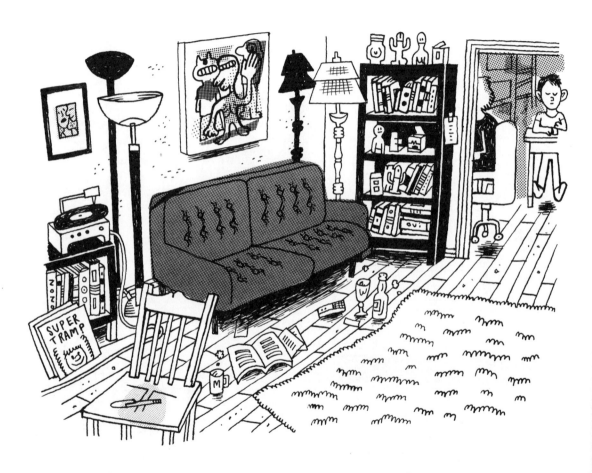

here is the living room.

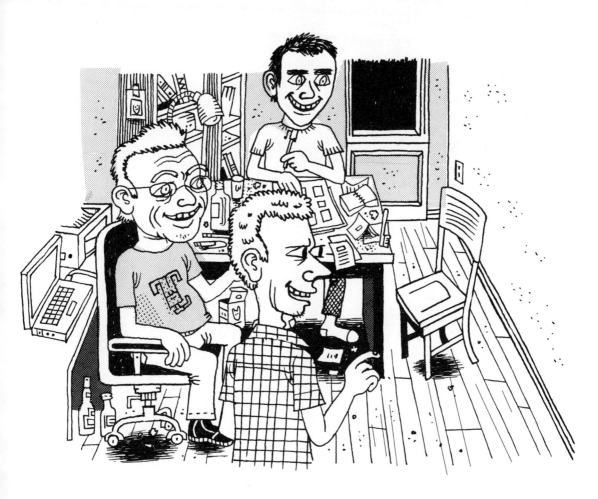

then i got to meet Michel's son, Paul, and Michel's friend, Jean-Louis.

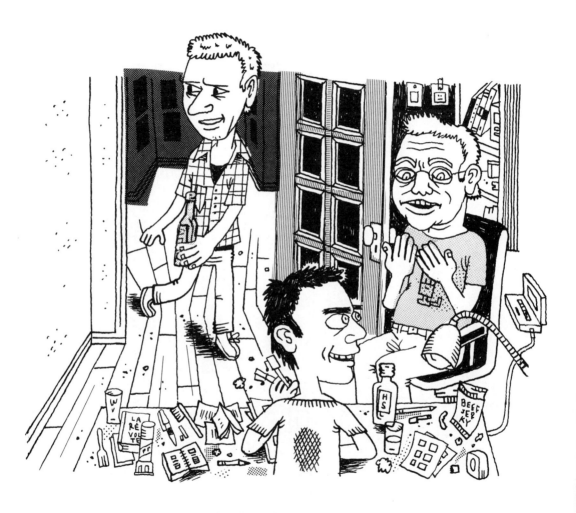

Michel offered me a beer.
Jean-Louis complained that Michel steals his crackers and Paul steals his beef jerky.

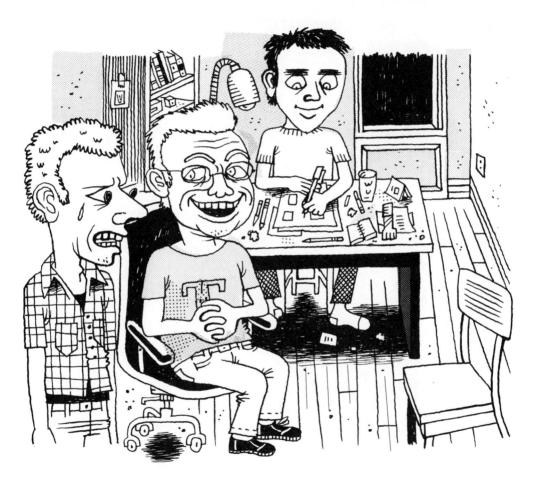

Michel cried: "see what Jean-Louis does he makes my son drink!"

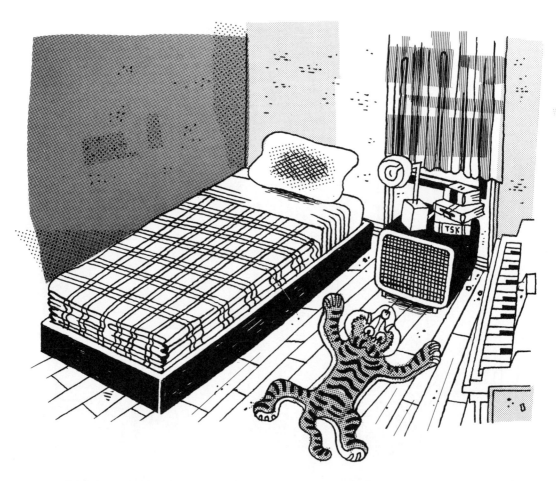

i felt i was in the Gondry reality show, if such a thing existed. a mad house.

we went to bed kind of late. it had been a very long day.

the next morning...

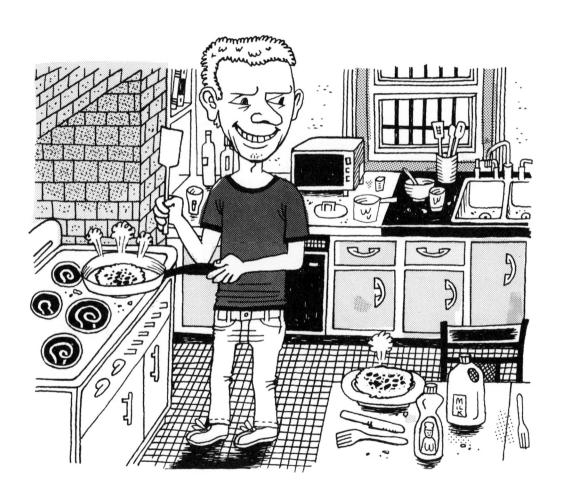

Michel made breakfast for us. it was made up of
slightly burned Aunt Jemima powder pancakes...

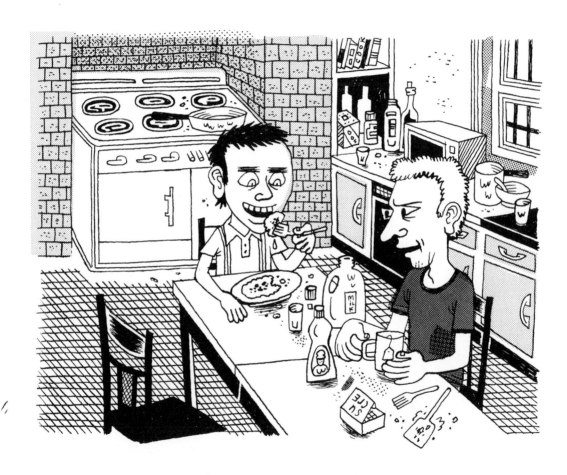

...and served with Aunt Jemima syrup.

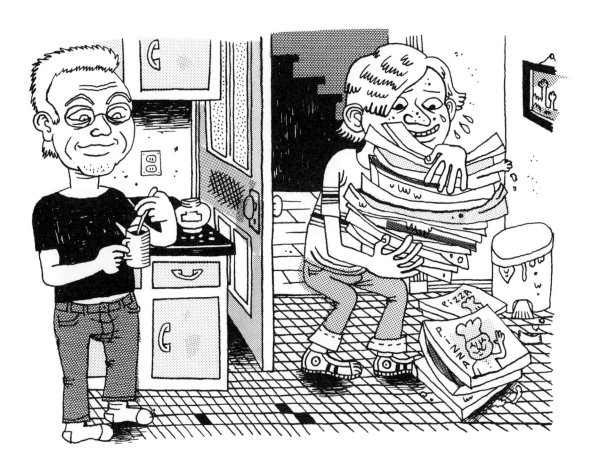

this young guy was piling up empty pizza boxes for the recycling.

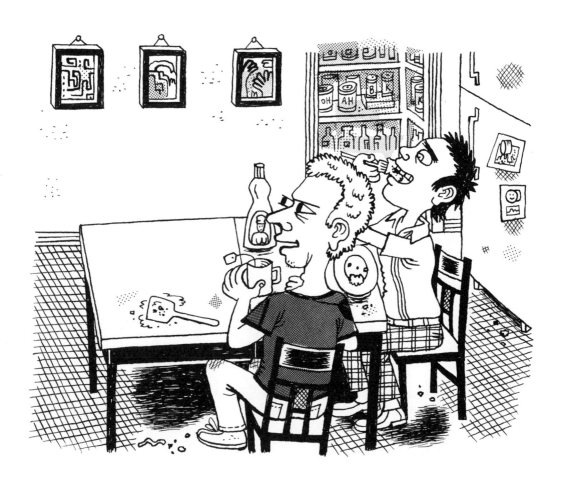

Paul said: "why do you need an intern to do that?"
Michel replied: "to be honest i am a bit ashamed of myself here."

time to start the day. Michel called a taxi.

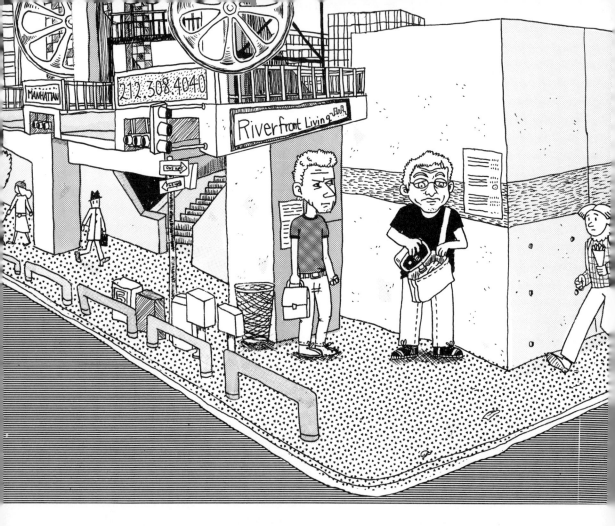

we had to go to the Roosevelt Island cablecar. Michel needed images of the city landscape for a videoclip he was working on at the moment.

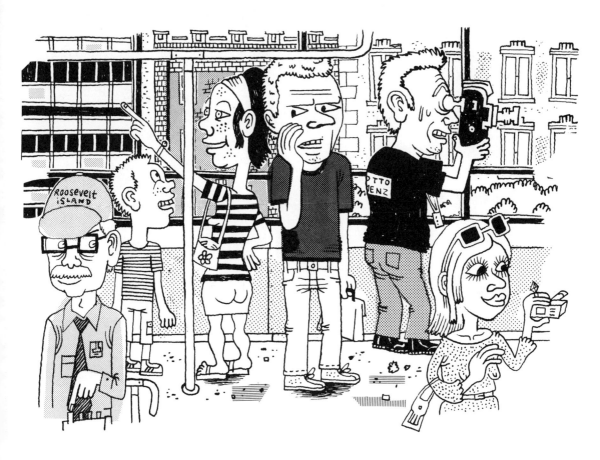

we were worried that the cablecar operator wouldn't let us film,
because of the ambient terrorist paranoia.

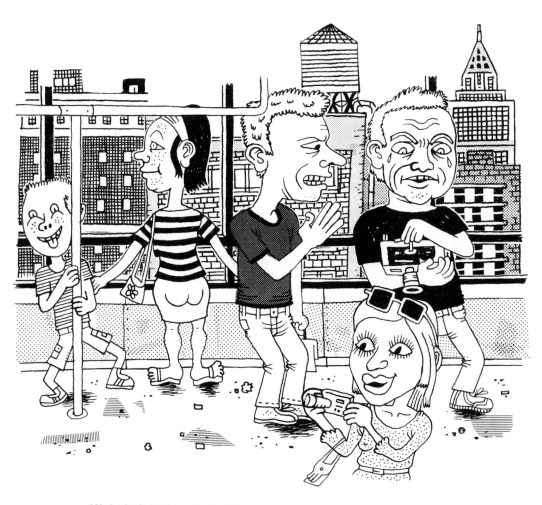

Michel picked on Jean-Louis because Jean-Louis was wearing a t-shirt with a film brand on it, when he asked him to be discreet.

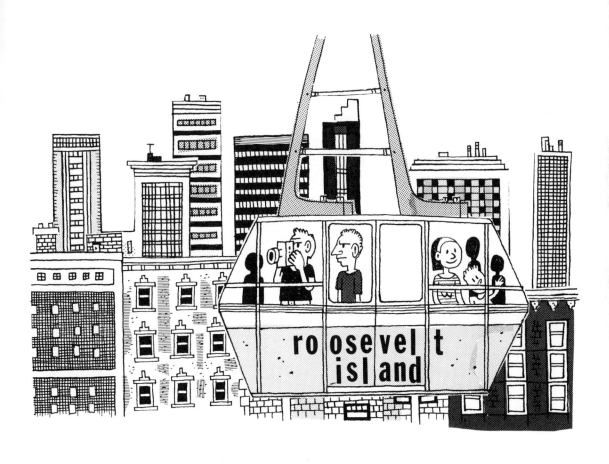

Michel and Jean-Louis quarreled all the way to the island.

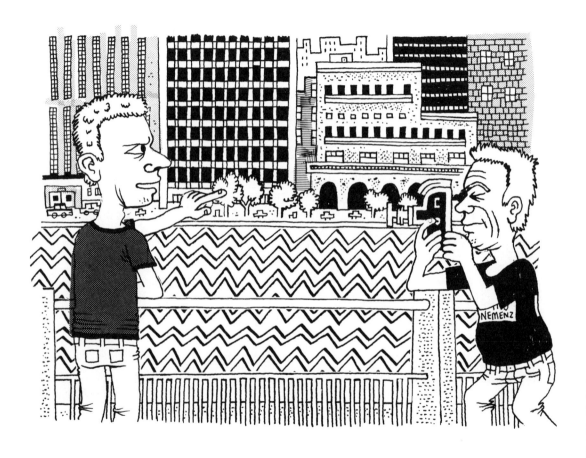

we looked at the water, at the buildings on the other side of the river,
where Paul's school was.

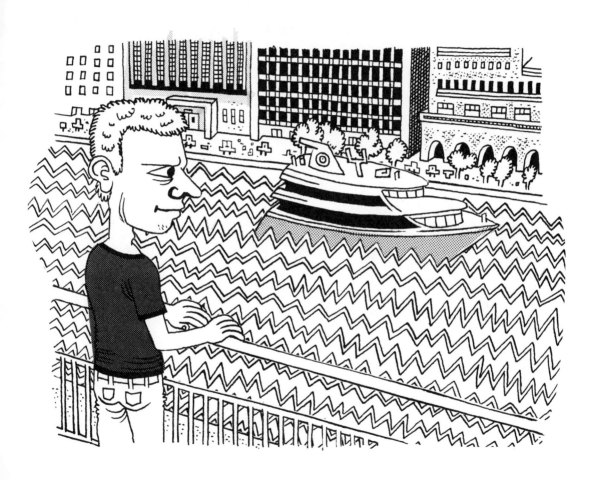

and where Paul was doing his high school final exams.

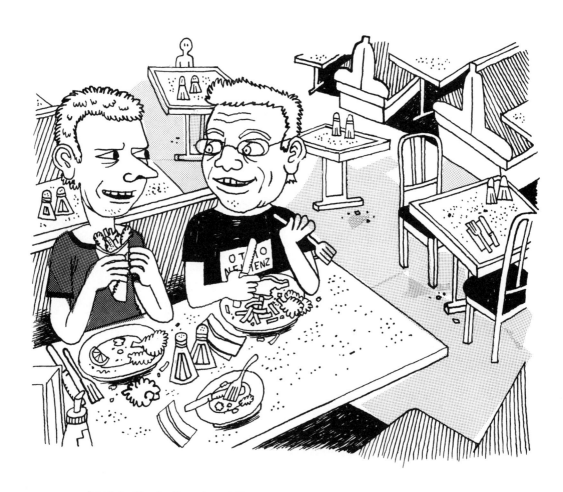

back in Manhattan: lunchtime. we went to a Moonstruck restaurant.
Michel kept on bugging Jean-Louis.

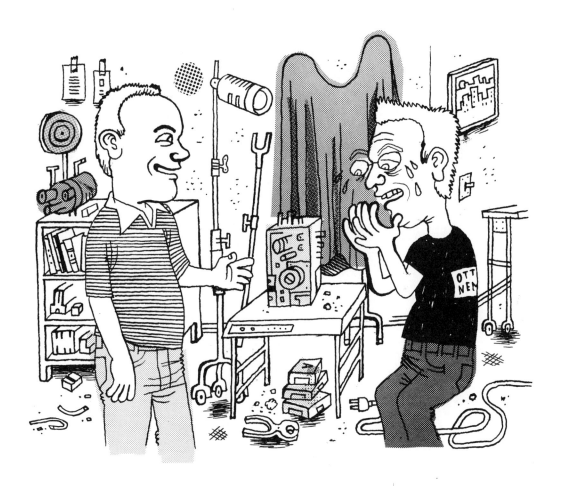

then we went to New Jersey to this animation film studio
to take pictures of my drawings. the place was truly a camera museum.

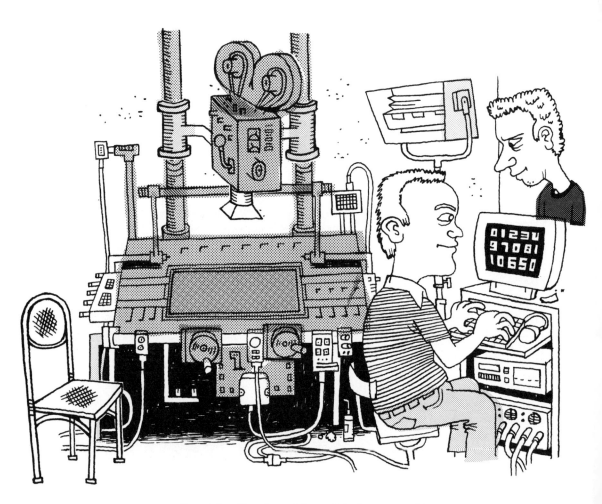

the animation bench was this huge machine
that looked way too big for the job it was doing.

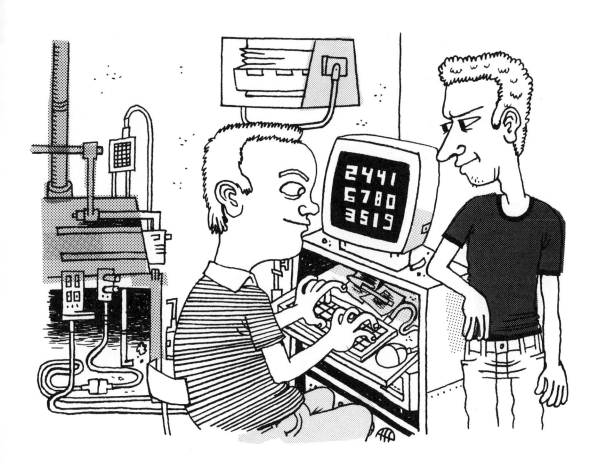

the whole set up was controlled by what looked like a 20 year old computer.

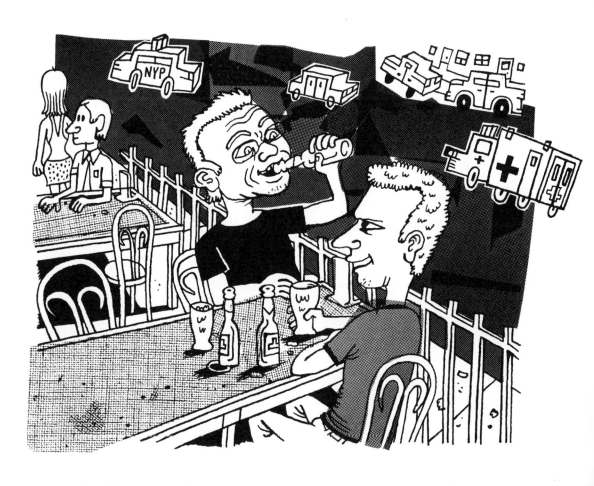

the job done, we drank some well-deserved cold beers at a terrace nearby.

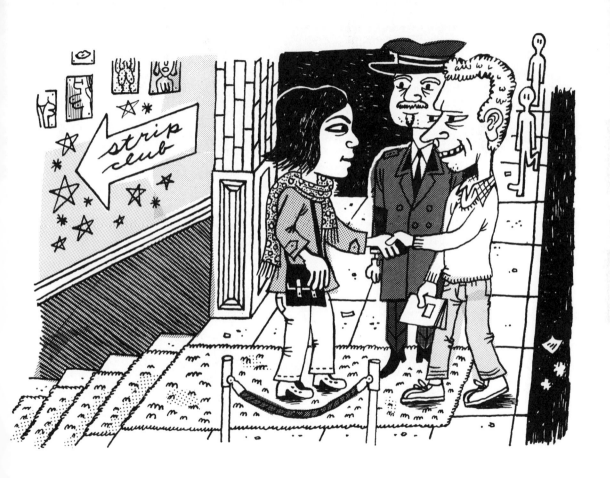

the next day evening, Michel and i went to a strip-club.
we met in front of the place with Shoko, a friend of his.

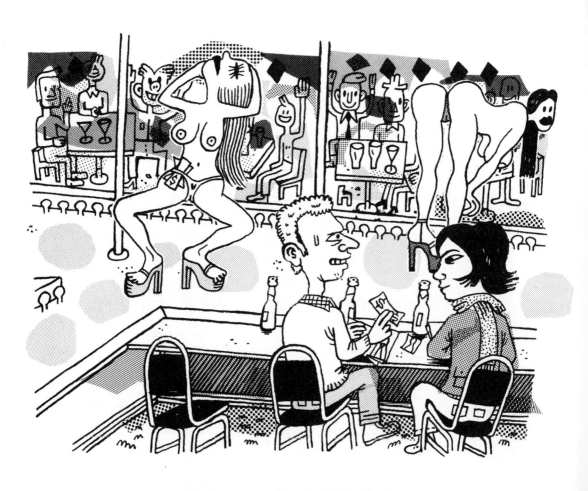

the plan was to draw the girls dancing.
we ordered beer and took out our sketchbooks.

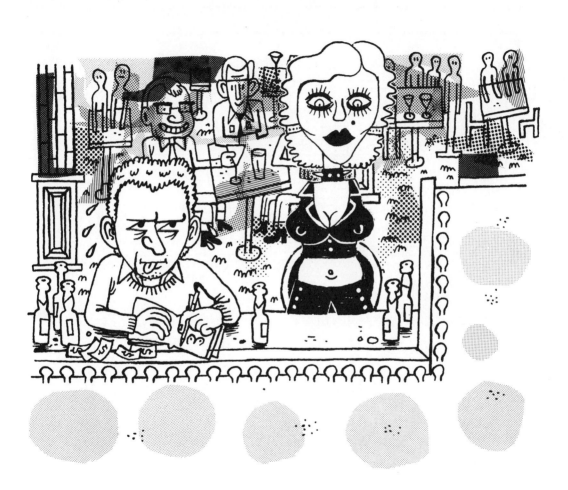

Michel got himself a massage from one of the girls.
he offered me one. i said no, but then yes.

the day after, i decided to go to Washington Heights, where i used to live back in 1991.

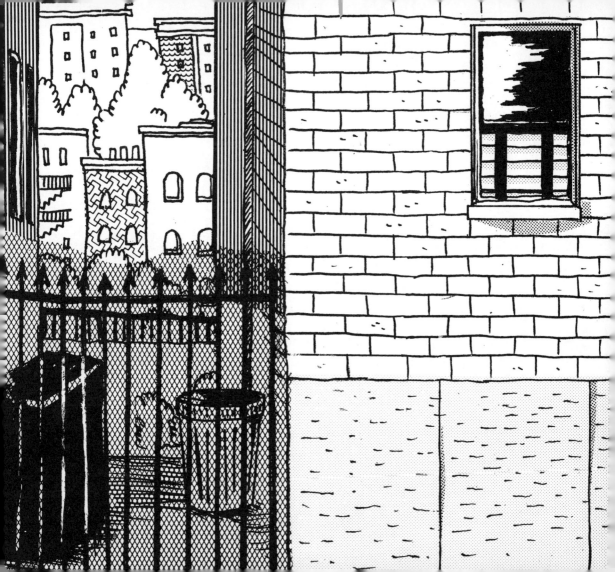

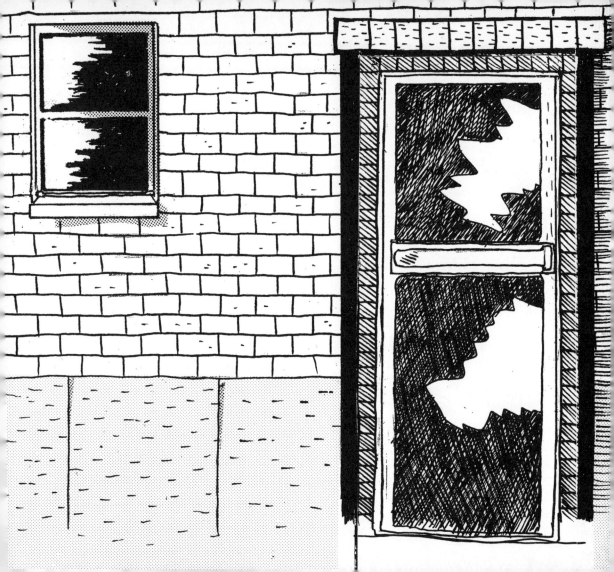

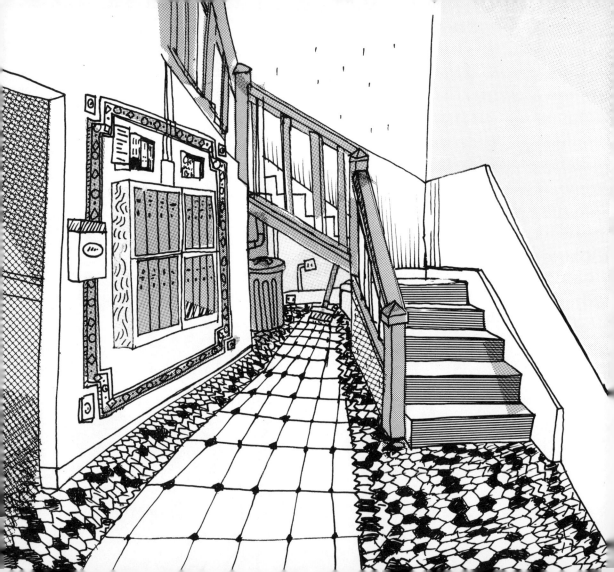

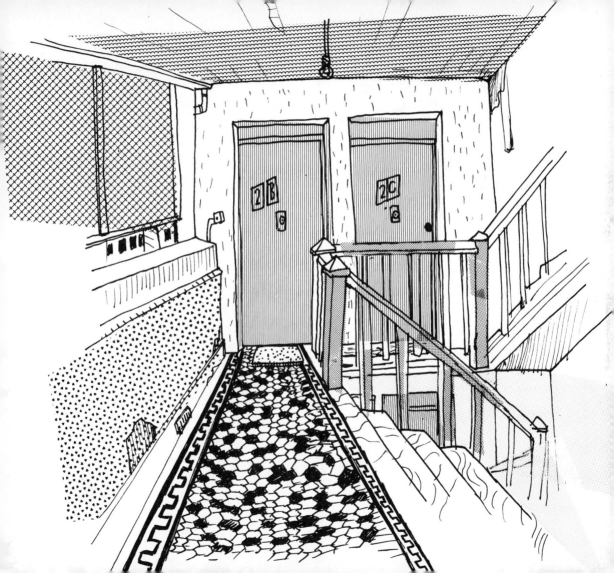

i could not even figure out which floor my apartment was on,
or even which front door was mine.

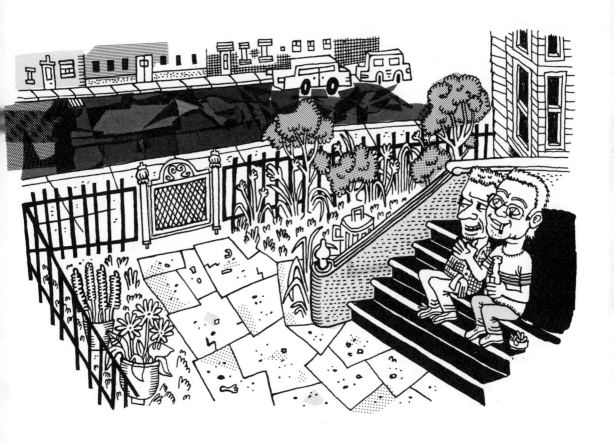

i bought groceries on my way back. Michel's fridge is always empty. i bought beer.

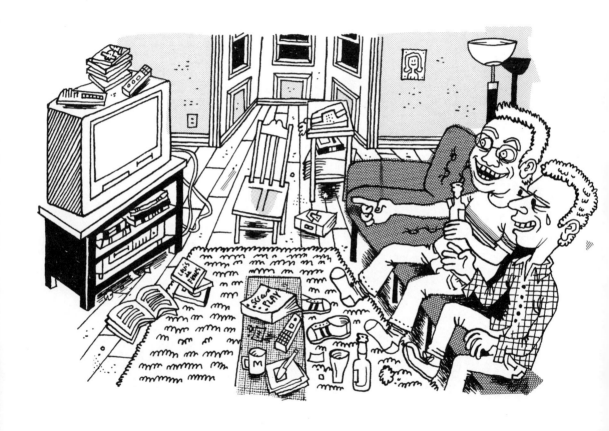

later that evening we watched an old Louis de Funès movie.

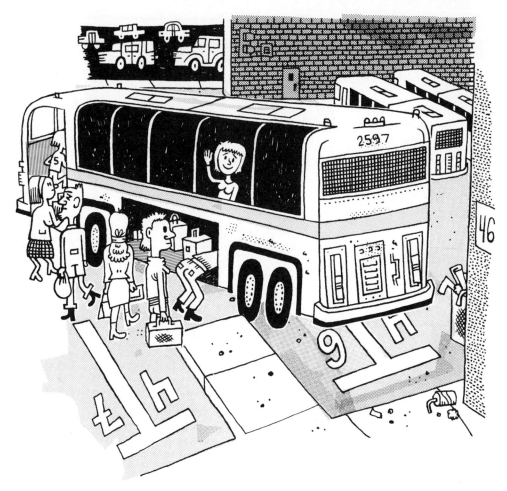

the next morning it was time for me to leave, to go back to Montréal.

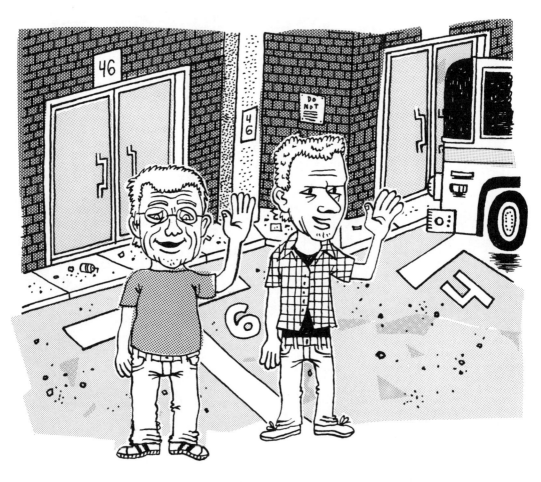

Michel and Jean-Louis took me to the bus depot to say good-bye.

it had been a fun trip, but i really had to go,
because i still had many drawings to do. i mean, tons of drawings!

My New New York Diary
Julie Doucet & Michel Gondry

Drawn by Julie Doucet
(except pages 54 and 69-74, drawn by Michel Gondry)
Directed by Michel Gondry
Produced by Raffi Adlan
Designed by Helene Silverman

PictureBox
PO Box 24744
Brooklyn NY 11202
www.pictureboxinc.com

ISBN 978-0-9845892-0-3. Available
through D.A.P./Distributed Art Publishers.

Printed in Singapore